THE
GREAT
PAPER TOY
SHOW

MAKIKO AZAKAMI

CHRONICLE BOOKS

SAN FRANCISCO

Off We Go!

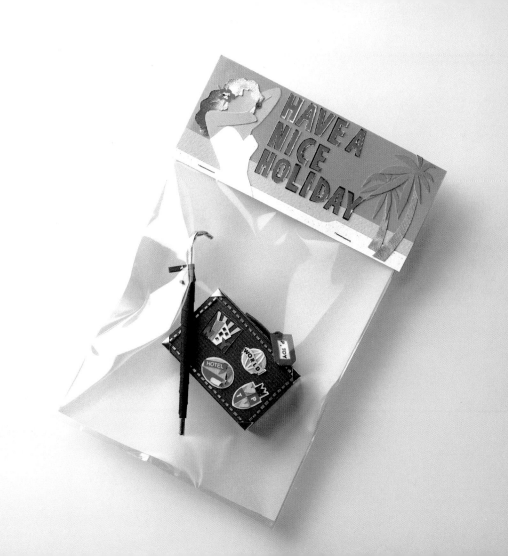

Winning Awards

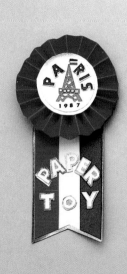

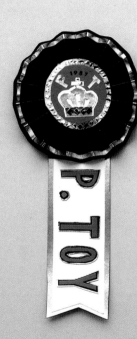

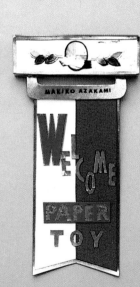

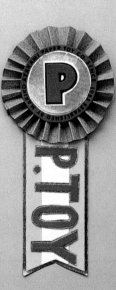

First Steps

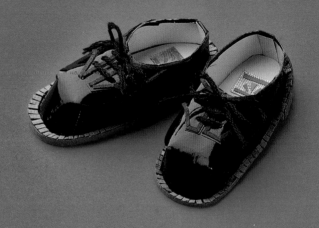

Summertime

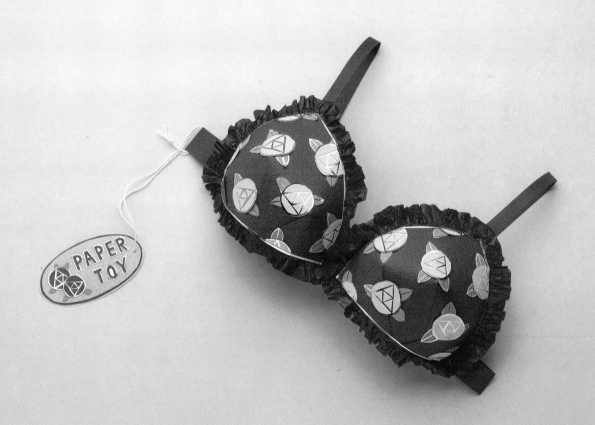

Sweet Tooth

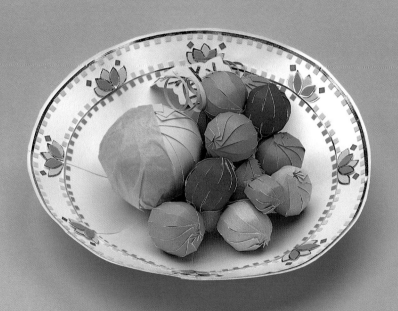

Show Time

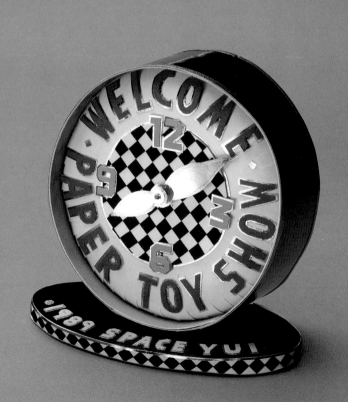

Uptown Girl

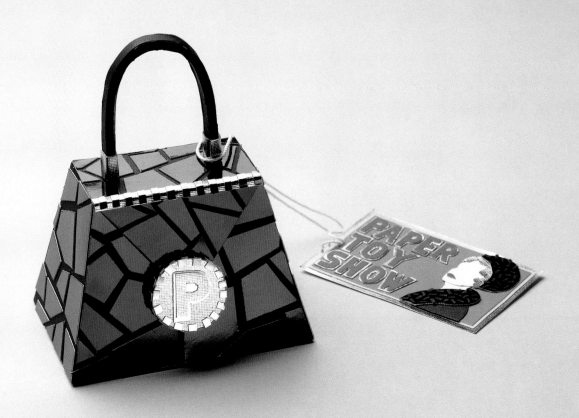

Tea Time

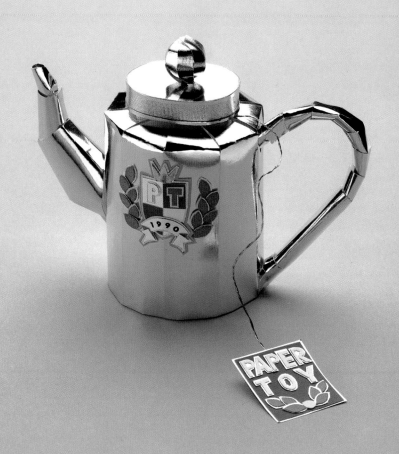

Hit Parade

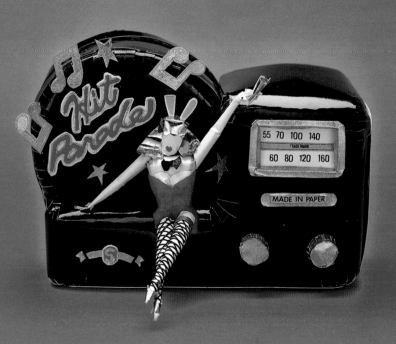

Amusements

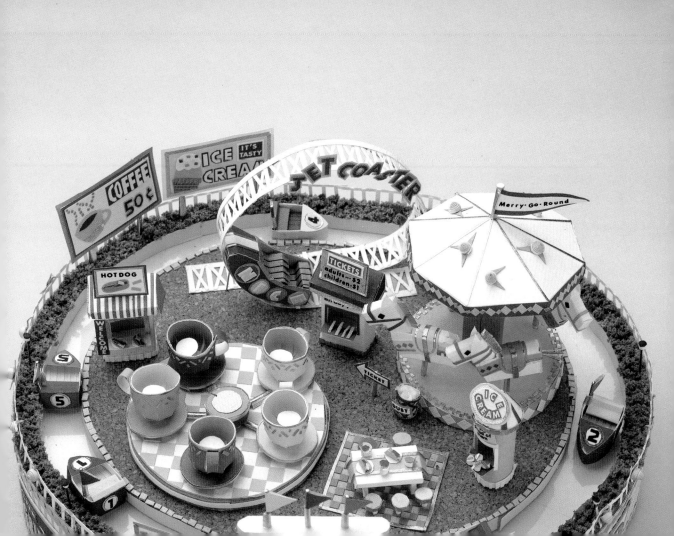

Here Comes the Bride

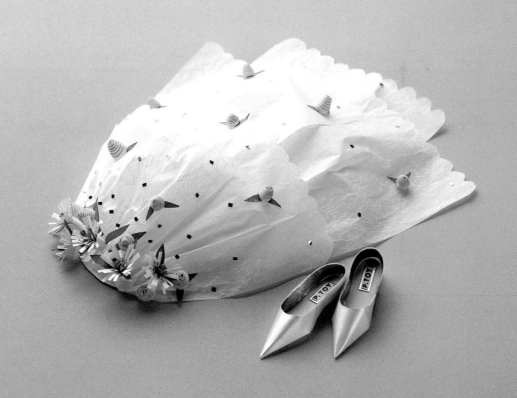

Easy Rider

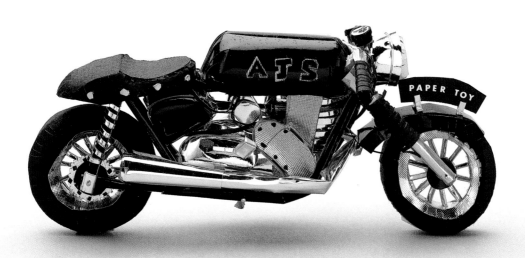

If the Shoe Fits

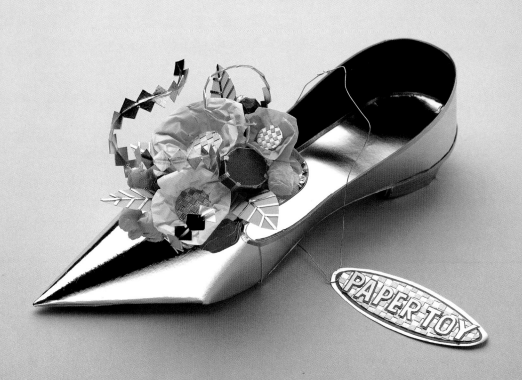

Ready to Go Robot

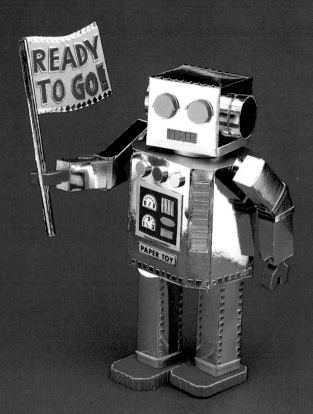

Fruit Suit

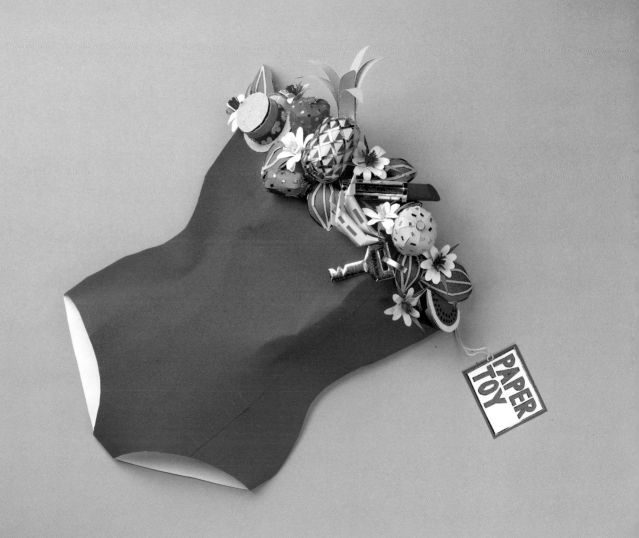

High Steppin'

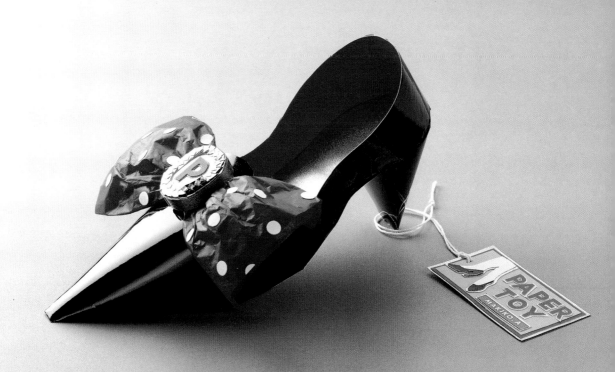

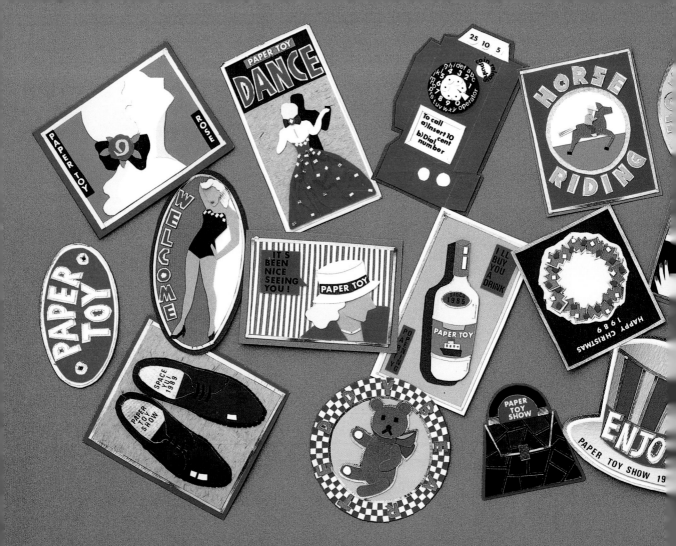

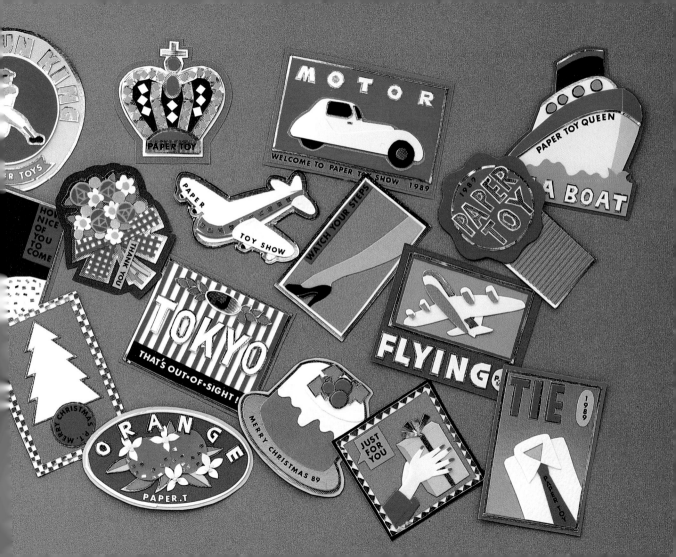

My Favorite Things

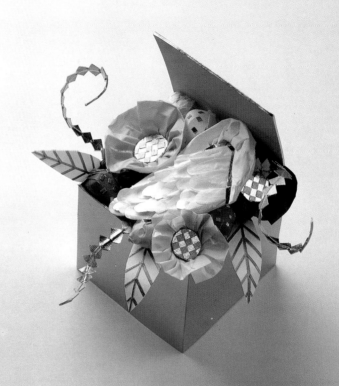

Just Married

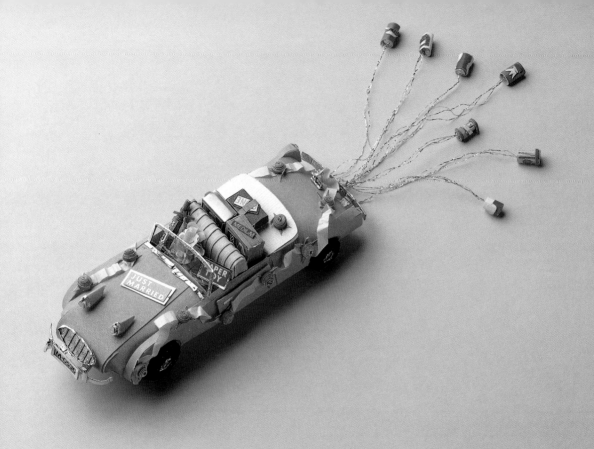

Smooth Sailing

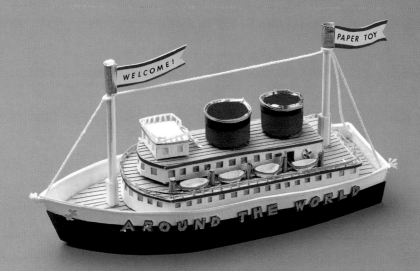

Bewitched

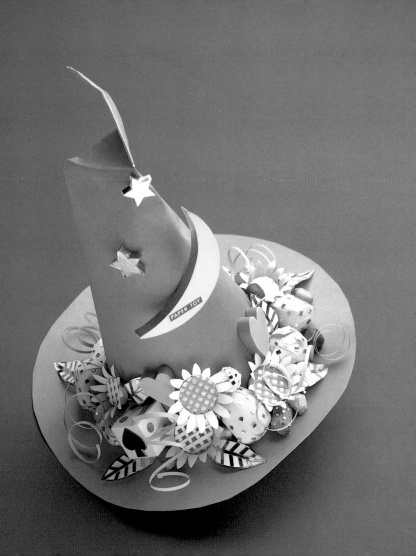

To the Moon

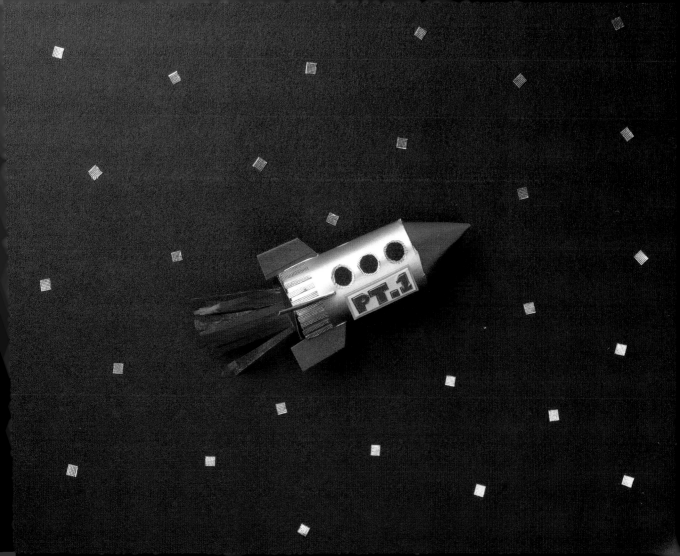

Mirror, Mirror

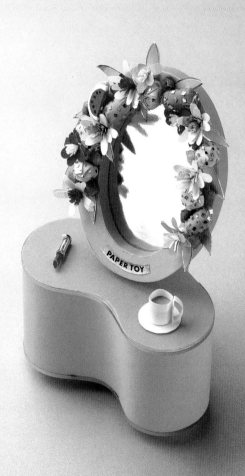

Party Girl

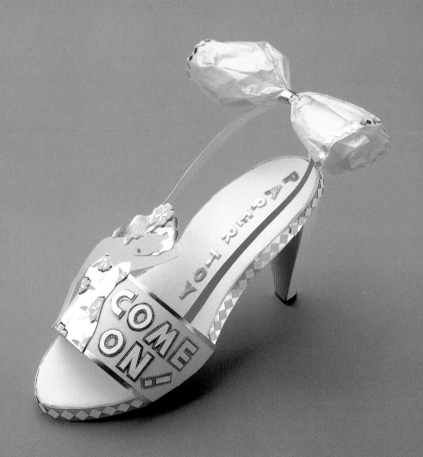

Prim and Proper

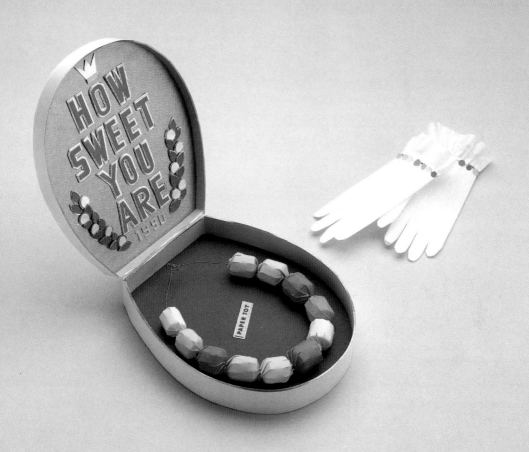

Spring is Here

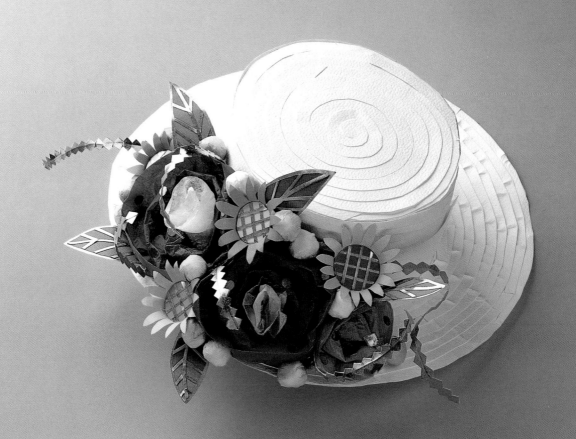

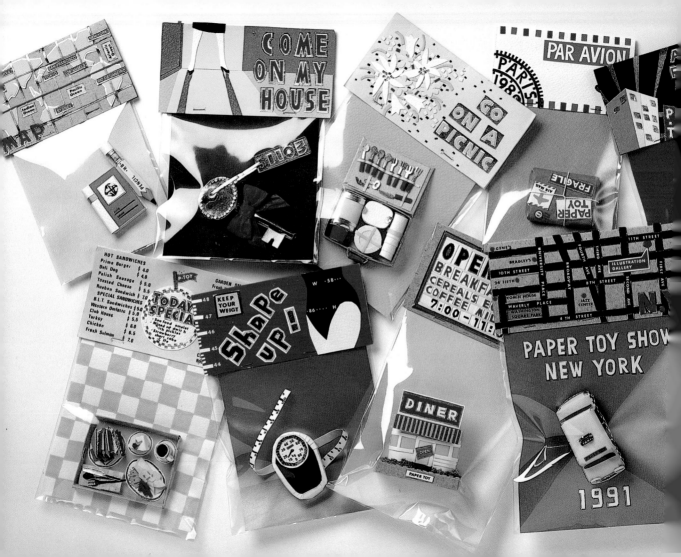

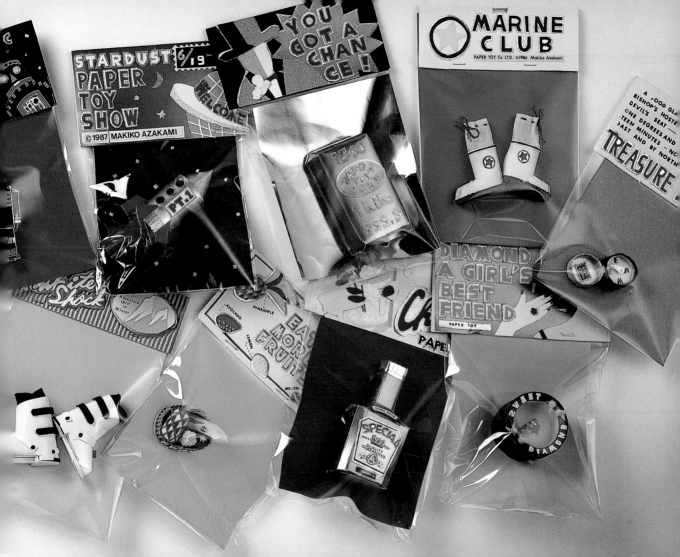

I've Got Your Number

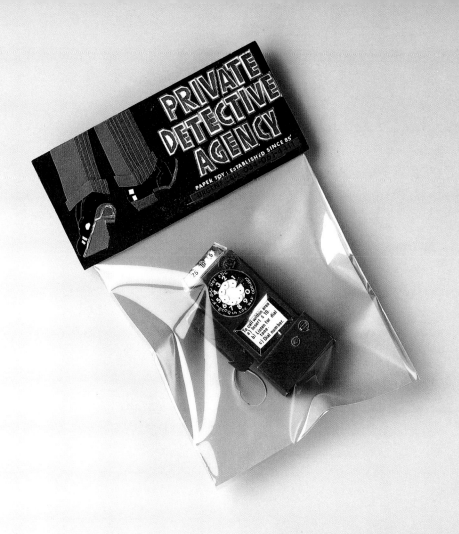

We Love the Fast Modern Way

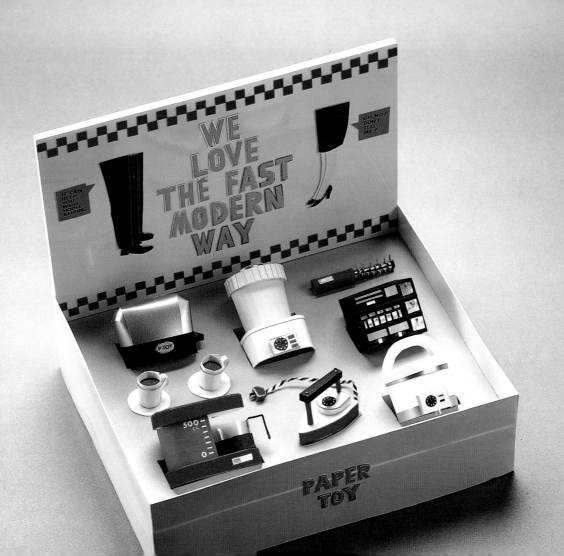

Room for Two

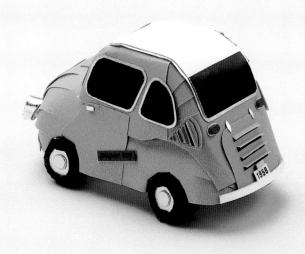

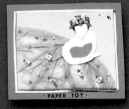

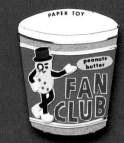

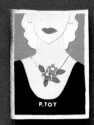

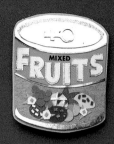

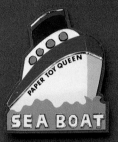

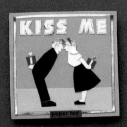

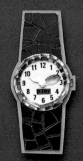

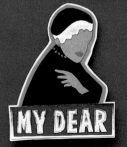

Perfect Fit

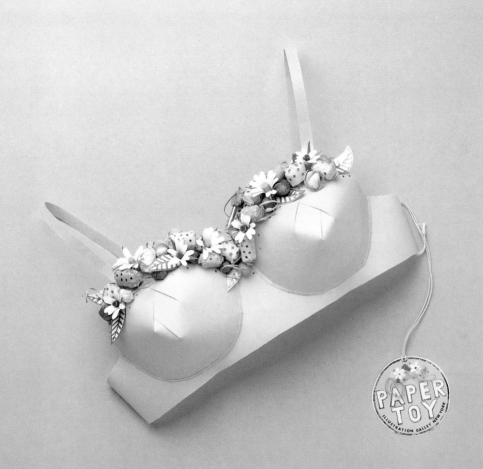

Life's Little Necessities

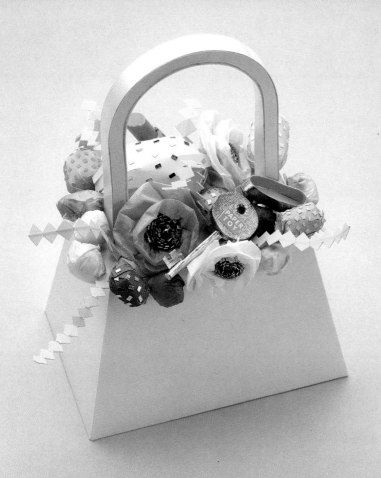

How Sweet It Is

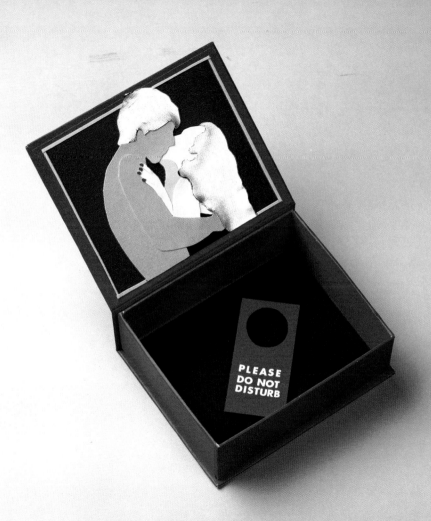

Diamonds are Forever

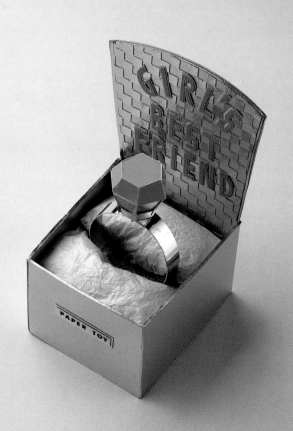

Light My Fire

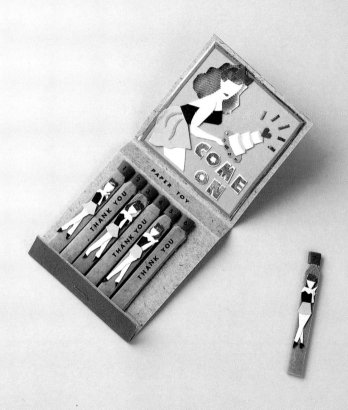

Dine and Dash

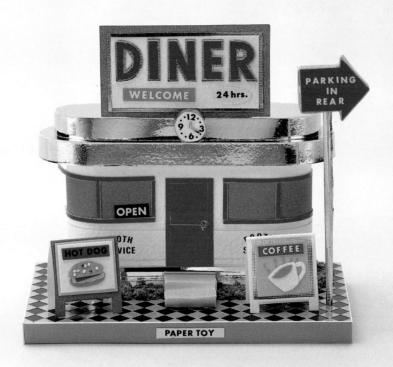

Timepiece

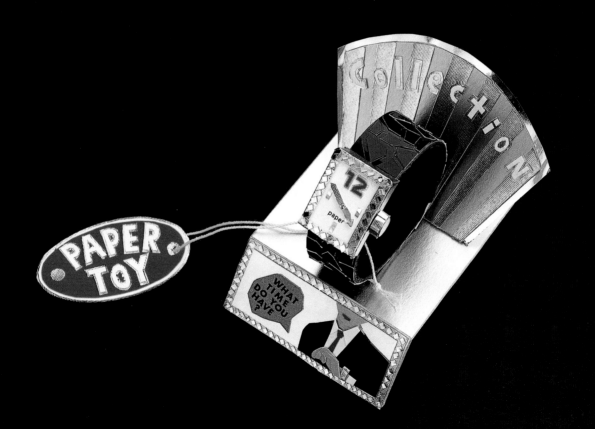

Spring Showers

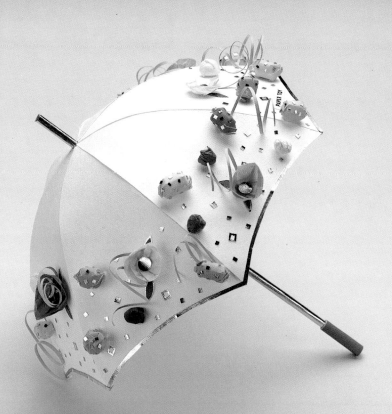

With Love from Me to You

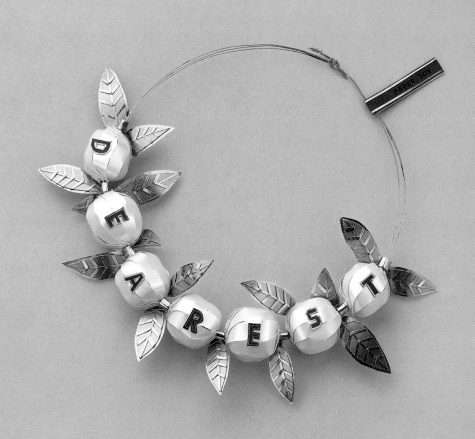

Ladies' Lunch

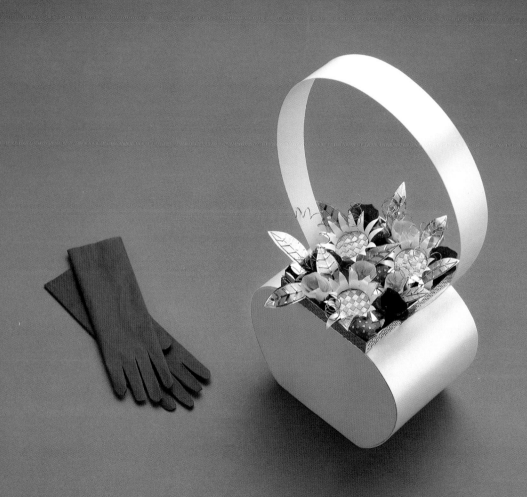

Small World

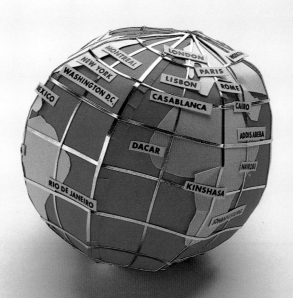

Special Occasion

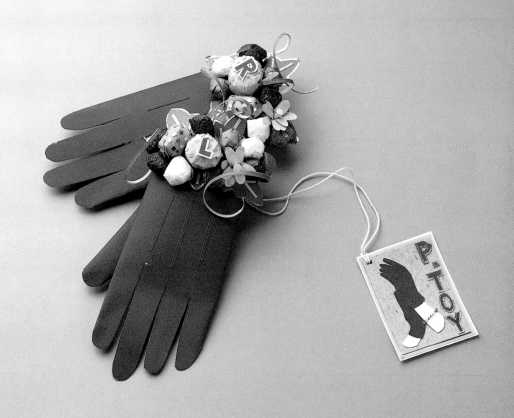

Good Times with Mr. Peanut

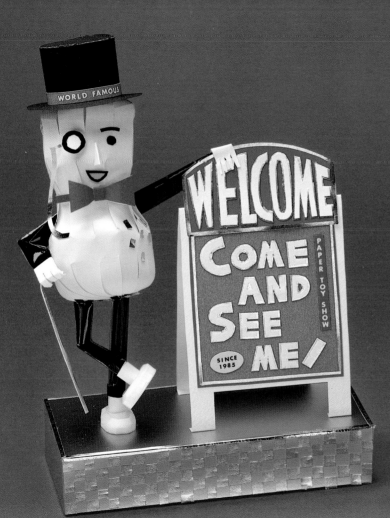

The Latest Fashions Seen at Ascot

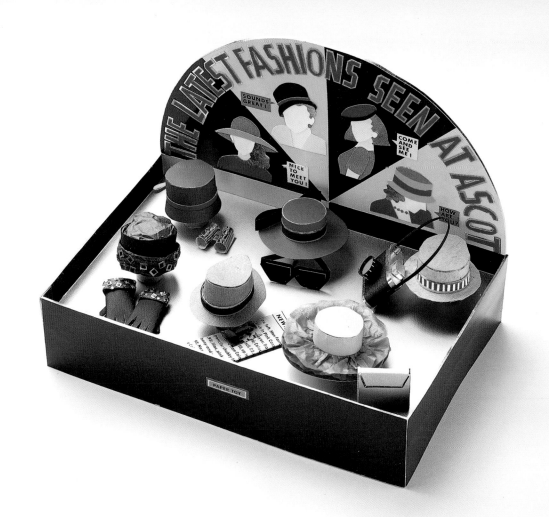

Makiko Azakami began making her magical paper toys in 1985. While a staff artist at Sony Creative Products, she snipped and pasted together a miniature paper Godzilla waving the Japanese flag. This beguiling creature inspired her to create more paper toys, and in a short time what started out as a hobby became a career.

She made her exhibition debut as a paper artist in 1985 at the Space Yui, an illustration gallery in Tokyo. Since then, she has had a one-woman show every fall at the gallery. Her work has been used to illustrate numerous bookjackets, magazine covers, fashion posters, and billboards across Japan and has been featured in many exhibitions, including twelve solo shows. Her first American show was held at The Illustration Gallery in New York. "Paper Toy" is the name that she chose to call her miniature three-dimensional paper objects. Ms. Azakami lives in Tokyo.

PAPER TOY

Summer 1990
W 5 ¼ x L 7 ½ x H1

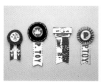

Winter 1987
W 2 ¾ x L 4 ½ x H ¾

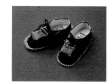

Summer 1985
W 1 ⅛ x L 2 ½ x H ⅝

Summer 1988
W 9 ¾ x L 1 ¾ x H 7

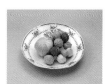

Autumn 1990
W 4 ¾ x L 4 ¼ x H 2 ¼

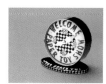

Autumn 1989
W 5 x L 2 ¾ x H 5

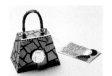

Winter 1989
W 3 ½ x L 2 ¼ x H 4

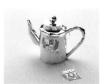

Autumn 1990
W 4 ¾ x L 2 ½ x H 4 ¼

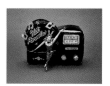

Winter 1985
W 6 x L 4 ¾ x H 4 ¼

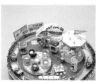

Autumn 1986
W 12 ½ x L 11 ¾ x H 6 ¼

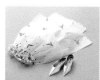

Summer 1990
W 5 ½ x L 7 x H 1 ½

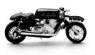

Spring 1985
W 6 x L 1 ½ x H 3

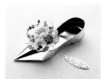

Spring 1990
W 9 x L 2 ¾ x H 4

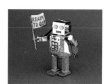

Winter 1989
W 3 ¼ x L 2 ¼ x H 5 ¾

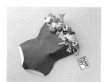

Spring 1989
W 7 ¾ x L 1 ¾ x H 11

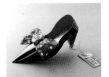

Winter 1988
W 5 x L 7 ¾ x H 3 ½

Autumn 1989

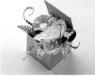

Summer 1990
W 2 ¼ x L 2 ¼ x H 4 ¼

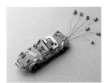

Winter 1985
W 1 ½ x L 5 x H 1

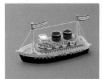

Spring 1985
W 2 x L 5 ¾ x H 3

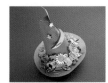

Summer 1990
W 9 x L 9 x H 10 ¼

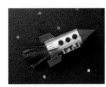

Winter 1987
W 1 ¼ x L 1 ¼ x H 4

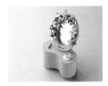

Winter 1990
W 3 ½ x L 2 ¼ x H 6

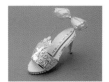

Spring 1989
W 2 ¾ x L 7 x H 5 ½

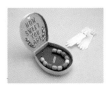

Summer 1990
W 4 ½ x L 9 x H 5

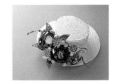

Spring 1989
W 10 ¾ x L 11 x H 4 ¼

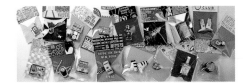

1986

Autumn 1986
W 7 ¾ x L 5 ½ x H 1

Autumn 1989
W 7 ¾ x L 6 ¾ x H 6 ¼

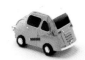

Spring 1989
W 2 x L 3 ¹/₄ x H 2 ¹/₄

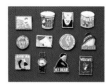

Summer 1989

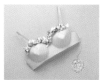

Winter 1989
W 9 ¹/₄ x L 3 ¹/₂ x H 7

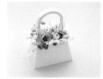

Spring 1989
W 4 ¹/₄ x L 3 ¹/₄ x H 5

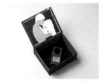

Summer 1988
W 4 x L 3 ¹/₂ x H 1 ¹/₂

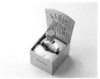

Autumn 1989
W 2 ¹/₈ x L 3 ¹/₈ x H 5

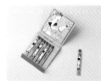

Autumn 1987
W 2 ¹/₂ x L 5 ¹/₂ x H ¹/₄

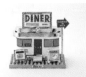

Summer 1989
W 4 ¹/₄ x L 2 ¹/₂ x H 3 ¹/₄

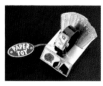

Spring 1986
W 2 ¹/₄ x L 3 ¹/₂ x H 3 ¹/₄

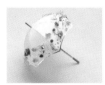

Spring 1990
W 6 ¹/₄ x L 6 ¹/₄ x H 7 ¹/₄

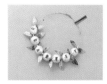

Summer 1990
W 5 ¹/₂ x L 6 x H 1 ¹/₄

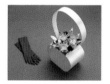

Winter 1990
W 4 ¹/₄ x L 2 ¹/₂ x H 9 ¹/₄

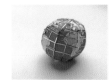

Autumn 1990
W 3 ¹/₂ x L 3 ¹/₂ x H 3 ¹/₂

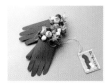

Autumn 1989
W 3 ¹/₄ x L 6 x H 1 ¹/₂

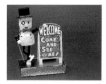

Summer 1988
W 6 x L 2 ¹/₄ x H 7

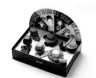

Autumn 1989
W 9 x L 6 x H 6 ¹/₂

First published in the United States in 1993 by Chronicle Books.

All rights reserved. No part of this book may be reproduced in
any form without written permission from Chronicle Books.

© 1990 by Makiko Azakami.
First published in 1990 by Ecco, an imprint of Dobunshoin, Tokyo, Japan.
Text © 1993 by Chronicle Books.

Printed in Hong Kong.

ISBN: 0-8118-0507-7

Library of Congress Cataloging in Publication Data available.

Cover design: Todd Reamon, Green Studios
Photography: Haruhiko Tanizaki

Distributed in Canada by
Raincoast Books
112 East Third Avenue
Vancouver, B.C. V5T 1C8

10 9 8 7 6 5 4 3 2 1

Chronicle Books
275 Fifth Street
San Francisco, California 94103